THE LITTLE THEATER OF VINCENT DARRÉ

Flammarion

The Little Theater of Vincent Darré

Foreword: Darré's Ark
by
LAURENCE BENAÏM

Text
by
ISABELLE ADJANI

AMIRA CASAR

ARIELLE DOMBASLE

EVA IONESCO

VALÉRIE LEMERCIER

Contents

- 6 — Villa Noailles
- 14 — An Exercice in Style
- 36 — Jean Cocteau
- 46 — Once Upon a Time at the Ritz
- 62 — BHL: Hôtel Europe
- 66 — Quadrille
- 74 — Gallery Installation
- 84 — Fashion: The Show Must Go On
- 104 — Palazzo Durini
- 108 — Luxury Living
- 114 — Spoleto Festival
- 120 — Let the Party Begin
- 134 — Rendezvous with AD
- 142 — Polterne Frau
- 152 — The Prince de Galles
- 160 — Holiday Homework
- 166 — The Biennale des Antiquaires
- 172 — Arielle on the Stage
- 190 — Mondrix
- 200 — Mon Manège à Moi

LAURENE BENAÏM

FOREWORD
DARRÉ'S ARK

Life is filled with pretense, but Vincent Darré has made illusion his accomplice. Eras for him are merely a shower of stars strewn across centuries and moments, across streets and cities, castles and fairy tales. Each object, beginning with the Octopus sconces from the Insomniac collection, holds the promise of a story. Everything about him is new and everything is a memory, and everything dazzles. As if he were sailing from one shore to another, a pink champagne evening. Vincent Darré adorns the blank page with precise, joyful, dynamic lines, transforming his little theater into a kind of fantastical marquee. He is both tightrope walker and juggler, ringmaster and squire, costumier and stage manager, an artist-conductor who soars above all judgements with an almost supernatural charm. His pencil box is his carriage, intuition his reason to be and to feel. Chic, the decades sit lightly on him, but there is no pretending to be young. His suns have false eyelashes; the main thing is not to imitate nor to reconstitute, but to play at life as seriously as possible, cards on the table. His character is poetically amplified by discoveries and encounters that heighten feelings to the point of making it a signature. As if the only reason to live was to play, to recreate, again and again, like an engineer of the imaginary. To stage and restage a scene rather than mounting it. And to pass from one folly to another, each face opening "like a big window onto a landscape." You would like to hold him back, though he would escape, slipping through the holes of the biographical nets—like Eloise at the Ritz—to trip up pretentiousness. In one stroke, killing off what believes itself eternal. This is the advantage that theater people have: they don't have an immortality complex. They have within them the quest for this "false paradise" so beloved by director Louis Jouvet—the awareness that a castle, whether of cards or stone, is a set. That princesses have both sorrows and dreams. Perhaps he himself, this son of intellectuals, who says he "experienced May 68 on the shoulders of his parents," is the first of his mirages. Beneath his air of a worldly dancer of the decorative arts, doesn't he, first and foremost, conceal the opposite? "I have always worked; a dandy does not work."

Trompe-l'oeil plays a magisterial role; wallpaper trumps pipes; caryatids, flowers, crowns, and trellises form a delightful troupe of acrobats, where everything seems eternally possible: there, a rabbit grasping a watch, here a pink flamingo posing in front of a page from a magazine, a corridor of telephones, "tables unfolding under parrot chandeliers." In Darré's grand ark is everything that makes Paris a City of Light, from Proust to the Palace nightclub. Truly fake, genuinely radiant beneath its celestial robes. He does not demand of his material a stringent order: it is malleable, closely related to the canvas, ready to build upon, the starting point for all the sun-kissed, ephemeral Edens. Like Jean Cocteau, he seems to address the magicians, to say to them: "Men of a thousand hands, your lies amaze us more than one poor truth."

Scroll shapes, costume balls, fairy dresses, gilding, fountains, torches, angels' wings, statues, flying carpets—with him, they emerge from the other side of time and at the same time find the hearts of those he makes manifest. Those of Marie-Laure, of Dalí, of the Duke and Duchess of Windsor, and of Chanel, of a Mediterranean villa, a Parisian mansion, and a Ritz transformed into an English castle for Kate Moss. Life as "*the show must go on*," between Technicolor opulence and decadence. From the stage to the backstage of a perpetual parade. An al dente collage. A scrapbook in 4D enhanced with tableaux vivants, fountains of ivy, and violin-playing bears. Architecture without limits, as far away from "décor" and its tired schemes as from the French designers with pretensions to interior design. The mismatched triumphs run along one line, returning texture to taste: a sense of wonder. An eye created from a thousand others.

While others feign a casual style, Vincent Darré, dressed to the nines, has the sass to pass for a dandy, completely in love with everything that fashion, in its superstition, shuns: the cursed color green, the favorite of Pierre Cardin. Happy in seersucker, irrepressible club stripes that nothing seems to bring down. Not even those who are gone, about whom he speaks in the present tense, nor the sleeping Paris that this tightrope walker of the golden ages awakens with a wave of his magic wand. The only thing missing here is his voice, the one that he uses to imitate Karl Lagerfeld, that brilliant caricaturist voyeur. An insatiable sketcher and the zeitgeist that he takes on in delicate bites. Pop before his time.

In his drawings, figures pass by: he fixes their attitudes and gestures with a glance, in a silent film of which he is witness, scriptwriter, director, and producer, the Parisian *truccatore*. Multiple and unique. Having refined the art of the withering glance with the master, Karl, *Carlito de Paname*. Free of nostalgia, but filled with memories: with him, the merest hint becomes a drawing. Initials V. D. The character plays his life every which way, like "a pocket Merlin," as Harper Lee described Truman Capote in *To Kill a Mockingbird*. But he is no mockingbird—radiant in flight; a singing fool in a rainbow. Painter of the Eiffel Tower, able to fall in love with a shipping crate, he doesn't pay homage, he teases, he talks with Bérard, Dalí, Gruau, Dior, and his crazy friends, pinning down swan women, lip sofas, and New Looks, one after the other, with unabashed joy. Darré the couturier of dreams, inspired by the Ballets Russes as much as by Richard Avedon and Stanley Donen, his roses are the cream of roses, Jacques Tati and his film *Les Vacances de Monsieur Hulot*, the house at Saint-Marc-sur-Mer remade into a store. A traveling cabinet of curiosities, his secrets are his trinkets. Age cannot wither him nor custom stale his infinite variety.

Training at Studio Berçot, chisel strokes, slights of hand, a keen eye.

Vincent Darré is at once twenty and a century old. In his look, his presence, he has composed a style, an enchantment, a device that sends everyone on their way, these Carabosses, the wicked fairies. In the name of fantasy, of the silhouette of his pencil line, of his laughter flying high at all hours. Vincent Darré assures us that he regards life "as a laboratory." One where the test tubes are paintbrushes and where, in front of a drawing table, for more than thirty years, he has been scouting, sampling, and marking everything that makes a fashion statement, having found the antidote for the worst disease: boredom.

In Paris and in Rome, Vincent Darré sweeps through the decades, concentrating them into a moment caught in watercolor: the stroke, the chance meeting, the spirit of the gesture that creates the allure, the sketch of an apparition. The perpetual promise of joy. His little theater of fashion like an aristocratic caravan floating along to a jazz tune. *Funny Face* forever.

Villa Noailles

The extraordinary architecture of Villa Noailles is filled with the echoes of legendary memories, of an eccentric life, of the Roaring Twenties, of the two patrons who knew no limits. Who hasn't dreamed of being one of their guests?

Jean-Pierre Blanc did exactly that, the year following my nomination as president of the jury for Design Parade Toulon: he offered me the Musée d'Art Moderne de Toulon to create a story for these places. In a frenzy, I invented a family of bohemian collectors while assiduously following the enthralling function of president. I invited a jury of friends, artists, designers, and interior architects to select the candidates' dossiers and to support them in their monumental and incredibly moving creative process.

This time, Jean-Pierre Blanc invited me to the famous villa, to transform the museum store. I imagined myself transported to another time, that it was in fact Marie-Laure and Charles de Noailles who had invited me. I was given carte blanche, and so created a folly. I think it's my most successful project, because the allusions beloved by the Noailles and the art movements they supported were my inspiration—bordering on obsessive—and they remain part of me. They gifted me with an inventive and humorous way of approaching the world, from Dadaism to surrealism.

Reconsidering that photo of Max Ernst and Dorothea Tanning on a throne, a plaster totem, evocative of the Mexican desert that was their home, I allowed myself to be transported by the lyricism of the Mediterranean. I thought of all those houses furnished with curves, all in white. Were they not in opposition to architect Robert Mallet-Stevens's precise angles? I let myself fall into a kind of trance, filled with Persian and Aztec profiles that would cover the walls, at times transforming into chimneys, at others, bookcases to display objects. Some faces would open to form frames, like large windows overlooking a landscape, with a fresco painted by the artist Matthieu Cossé. This was the antithesis of my white universe. I worked with a palette of primary colors and made fauvist-inspired figurative drawings, creating a trompe-l'oeil of the Villa Noailles.

The cubist gardens, the luscious gilt clouds on the ground, a table in the form of a wave on the right, and we entered a greenhouse with its pre-Columbian ghosts, their honeycombed bodies transformed into shelves, their heads blooming as jardinières, with cacti enthroned, protected from the Mediterranean sun by linen sails.

My almost unattainable fantasy was masterfully executed by two brothers from the team, with such candor and beauty that it was as if Jean Cocteau himself had sent them to me, reminding me that nothing is impossible for those who dare to dream: the meetings, with the painter, the artisans, and myself would have made him smile.

The former owners would have seen the eternal in the conversation. We were beyond the whisper of death.

Alas, this wonderful project had a short life, with the ephemeral enterprise coming to an end the following year. Despite the sunlit memories, there remains in my heart an indelible trace of sorrow.

THE PAINTERLY TOUCH OF MATTHIEU COSSÉ'S GORGEOUS FRESCOES

LES TROMPETTES

TWO BROTHERS,
FROM THE "MAKES PROJECTS" TEAM,
DID AN INCREDIBLE JOB

MY PROFILES TRANSFORMED INTO GARDEN BOOKCASES

An Exercise in Style

Exercises in style are always surprising. I know this from working for different brands, from Prada to Blumarine, Fendi, and Moschino: you have to take their history and reinterpret them, transforming their character.

When Cointreau asked me to design the bottle for its 170th anniversary, I delved not only into the iconography of all the different labels and all the advertising, but also into the bottle's extremely modern shape, which to me resembles a perfume bottle.

When I learned that the liqueur is made up of a thousand flavors, interpreted as a perfumer's "nose" would, I designed four different labels, in varied palettes ranging from orange to blue, and black and white, to envelop all four sides of this cubist bottle, making it enticing from every side.

The exercise for the jeweler Fred was very different. Hubert de Malherbe introduced me to Fred Samuel's granddaughter, who dreamt of a travel book telling the story of her grandfather's life and career. I was thus inspired by everything that her grandfather had said over the course of his professional life. They were the keys to the project, following the footsteps of this elegant jewelry pioneer. All that was left for me was to illustrate each of his phrases, going on each adventure with him, to the extent of transforming myself into a colorful character. We made little films that were a humorous accompaniment to the watercolors.

The commission from Christian Dior was different again, an Advent calendar with its twenty-four doors, something I'd dreamed of since childhood. I am a devout admirer of the style the couturier invented: his New Look perfectly captures the couture spirit of the 1950s. Thinking about his artist friends, such as Bérard, who decorated his first boutique, I felt completely in my element, telling the story of the fashion house in drawings. A cross-section of the building revealed the life of this famous Avenue Montaigne address. Everything was there, from the workshops to the fitting rooms and the catwalk on the main staircase, all brilliant in shades of gray, gold, and silver, the designer's preferred palette.

The most unexpected proposal, though, has been La Redoute asking me to design a chair. Introduced by Sylvie Barsacq, I met the enthusiastic team, and an armchair with modernist 1950s lines was born, bearing four different textiles: spots, zigzags, checks, and plain primary color. A cartoon-inspired vision!

For the staging of this chair, I had four sets made, recreating a little theater, upholstered in each of the fabrics and furnished with a selection I made from the catalog. I couldn't hide my excitement when I saw the result!

The most recent exercise was with Toulemonde Bochart, designing three rugs: Bleu des Yeux (Blue Eyes), Songe Nocturne (Night Dream), and Puzzle Nuageux (Cloudy Puzzle); geometrical shapes created thanks to the house's expertise.

The proposal from the ancestral home of French kitchens, Mobalpa, was surreal: "Vincent, we'd like you to design your dream kitchen for us; you've got carte blanche." It took me only a moment to accept the challenge and to launch into designing a metaphysical kitchen with a cubist nod to the Memphis group. From all this inspiration, a green kitchen came to life under my brush, a small architectural theater, a baroque folly, which, to my great surprise, was enthusiastically received by the company! The result was intensely colorful!

Cocktails D'AUJOURD'HUI, *Verres* D'AUTREFOIS

LABELS LIKE PAINTINGS FOR MY COINTREAU BOTTLE

vos amis aiment les fleurs!

DONNEZ-LEUR CETTE JOIE !

e des fleurs de pommier"

Voici, en coupe, la maison Christian Dior

ADVENT CALENDAR FOR CHRISTIAN DIOR

ENCOUNTER(S) WITH
VINCENT DARRÉ

A CURIOSITY IN HIS OWN RIGHT, VINCENT DARRÉ RESEMBLES HIS WHIMSICAL AND BIZARRE DÉCORS. FALSELY CLASSICAL AND CRAZY CLEVER, FOR DIOR MAGAZINE HE DECIPHERS AND DESCRIBES THE EMOTION(S) BEHIND MAISON CHRISTIAN DIOR PERFUMES. ENCOUNTER(S) BY MARIE AUDRAN

LIGNE NOUVELLE

entrez dans la Danse!

Christian Dior habille les jambes

...nous serons en retard pour le déjeuner

VINCENT DARRÉ

I DESIGNED AN ARMCHAIR FOR LA REDOUTE

VOUS PARTEZ TARD EN VACANCES

THREE PRINTS TAKE THE STAGE

MARIE

MAISON FRED
TOKYO

FRED

J'étais si heureux d'emmener ma femme sur la Côte d'Azur à l'hôtel Negresco

3. Première carte de visite de Fred Samuel, en 1936.
First business card of Fred Samuel, 1936.

4. Fred Samuel devant l'hôtel Le Negresco, à Nice, en 1930.
Fred Samuel in front of the Negresco Hotel in Nice, 1930.

Époque délicieuse où j'avais la chance de coiffer les têtes couronnées des plus belles pierres

H.R.H The Prince of

I ILLUSTRATED THE STORY OF FRED SAMUEL, ADVENTURER AND JEWELER

AN INCREDIBLE OPPORTUNITY TO FILM IN JEAN COCTEAU'S CHAPEL

une leçon de Peinture

MY DESIGNS
TRANSFORMED INTO FLYING CARPETS
FOR TOULEMONDE BOCHART

58 PAS COMME LES AUTRES

A METAPHYSICAL KITCHEN STAGED FOR MOBALPA

1° Choisissez votre dessert de Noël…

DE PROBLÈME!

W

Jean Cocteau

Cocteau is part of my life. A mentor, an inspiration in whom I see myself reflected. Like him, I am a jack-of-all-trades; I understand his anxieties because I live with them every day; eternally misunderstood, I feel connected to him. People think I'm superficial, a social butterfly, crazy, an eccentric; in a world where power is king, I play a game of hide and seek, following my dreams.

The day Arielle told me about her project for a film on the poet, I jumped for joy. It was to be a musical based on Cocteau's poems, set to music by Philippe Eveno, following the story of Jean's love for Radiguet. Director Mademoiselle Dombasle appointed me art director, set and costume designer, director of casting, and in the end, I even edited the film!

Filming began in Tangier, in August. Friends came along with us on this delightful adventure, including Marisa Berenson—vacationing at Le Mirage—who found herself in the role of the Marquise Casati. She appeared at Raymond Radiguet's funeral, in the Caves of Hercules, following a coffin built in the souks in the middle of Ramadan, carried by Moroccan children wearing black bodysuits and rhinestone-decorated headdresses I bought at the Erté sale at the Folies Bergère!

Fleur Demery—my wonderful collaborator—and I found ourselves dressing extras discovered at random on the street. We built a cardboard theater; like the poet we assembled a lyrical temple from paint and bed sheets.

Filming went on, bringing, in our euphoric delirium, many on board this ephemeral ship: Philippe Katerine as Nijinsky, Julie Depardieu as Nyx, Audrey Marnay as Coco Chanel, Valérie Donzelli as Valentine Hugo, Jérémie Elkaïm as the Comte de Beaumont, Hélène Fillières as the Comtesse de Noailles, Niels Schneider as Maurice Sachs, Ariel Wizman as Tristan Tzara, Farida Khelfa as Yvette, and Ali Mahdavi as Auric.

The list is endless and the film, *Opium*, went to Cannes, a farandole on the red carpet, choreographed by our audacious producer, François Margolin.

Hommage a Jean Cocteau

La Folle Équipée de Marie-Caroline

Bonus
Sur les traces de Jean Cocteau
Bio/filmographies
Galerie photos
Bande-annonce

Menu

OPIUM, THE FILM BY ARIELLE THAT I ART DIRECTED

Voyage

MYSTÉRIEUX PARFUM DE L'AMOUR MASQUÉ
MASCARADE
L. PIVER PARIS

ASCARADE

l'Emouvant

I DID THE SETS, THE COSTUMES, EVEN THE CASTING

ORNEZ VOTRE MAISON AVEC LES TRÉSORS DE

Le fantôme du désir

la femme chic ne serait plus ELLE

Le petit garçon et le Sortilèges de Jalna

AVEZ-VOUS LE DESTIN HOLLYWOOD ?

Sans sa parure lingerie

ARTS MÉNAGERS

L'Homme aux Yeux d'Or

KARL LAGERFELD IMMORTALIZED THE COCTEAU GANG

Arielle Dombasle
Doux baisers

I first met Vincent Darré on the stairs of the Paris Opéra, in 1985 or 1986. Rather than climbing the stairs, he was dancing up them with the grace and perfection of a Fred Astaire, already a virtuoso in his every step. He and a friend were guiding two polyvinyl fluorescent dogs at the end of a wire leash, twisting like Giacomettis, to the rhythm of their master's gestures. He nicknamed them Karl and Yves—little Dada mobiles that flavored all his outings with their ironic presence.

I knew he came out of Studio Berçot, that he'd designed costumes for Alfredo Arias, and collaborated with Martial Beraud and Pierre Le-Tan, that Andrée Putman, for whom he'd designed sets, adored him, that he was at the forefront of every trend, that he and Karl Lagerfeld were friends, that they worked together, with their imagination, tumult, virtuosity, and laughter. I knew he was a marvelous draftsman, that he loved German expressionist cinema, and that he could sing every interwar song. That he had read everything by Guitry and Cocteau, Genet's *Notre-Dame-des-Fleurs* and Bataille's *Le Bleu du Ciel*, that he could recognize a shot by René Clair or Jean Grémillon at a glance, that he could describe every scene of *The Scarlet Empress* with Marlene Dietrich, that he knew everything to be known about *Les Perles de la Couronne* and that *Les Visiteurs du Soir* sometimes visited him.

I knew, or at least I felt, that he was attuned to the essential: a voice, a gesture, a certain way of clenching a fist or stretching a leg—the arithmetic of bodies, the physics of souls. He had lived his Palace nightclub period, when he was the "prince of staging on a shoestring" for legendary soirées. As a child prodigy, a mad scientist of taste and a blending of genres, he had worked for Prada and Fendi. In his imaginary museum, Max Ernst and Yves Tanguy, Christian Bérard and Francis Bacon, all lived together, alongside laboratory objects and optical glasses, wicker mannequins, silver-threaded brocade, Knoll armchairs, Vietnamese lacquerware, anatomy charts, Le Corbusier drawings, faceted mirrors, and Lurçat tapestries. A manifold being, a collector with a magic pencil, a genius of styles, but also the nephew of Jorge Semprún and the son of sociologist Jean-Pierre Darré, who says he prefers a beautiful book to the most fascinating gossip. This mirror of our times, a vulnerable, mysterious character straight from a childhood of obsessive rituals, this elegant, rebellious man, this live wire with the body of a toreador, whose gaiety caught the mystery in the air, this prince without a kingdom, immediately became my friend.

In 2016, he opened the Maison Vincent Darré, a fantastical and dramatic extension of his perennial avant-garde spirit. On Rue Royale, at number 13, this man, alert to his era and to himself, built his "place" for artistic décor, in a geometry of perspectives à la Borges, an interweaving of metal and mirrors. Maison Darré remains a step ahead—and above! A store, a gallery really, a melancholic and somber Olympus, the very essence of the unexpected, with the strange its guiding principle, a phantom project where Eastern lacquerware visits Dante's Inferno. A vision of a joyous apocalypse, created with the candor of a deranged Minotaur. Carpets, trays, meridians, trompe-l'oeil, unique one-offs, transformed animals, modern fancies for converted post-punks: everything is there; everything is him.

As a friend, Vincent is delightful, a companion for every kind of wandering. Vincent is curiosity itself, with an exquisite sensitivity, and the vision that makes tomorrow's fashion. Vincent is style. He is the Pasolinian rogue with leather slippers. Vincent is suffering, filled with joy. The angel Heurtebise has passed by.

Then there was Opium, the film I decided to make based on Jean Cocteau's *Journal d'une Désintoxication*. Our dear, formidable Cocteau, the model and master of Vincent and me, playwright, novelist, filmmaker, prince of poets—we had to be equal to this prodigy.

We started by constructing the film around the musical setting of the poems of the very young Cocteau, during his passionate love story with Raymond Radiguet, "when the blood of a poet met the devil in the flesh."

Again, Vincent was the first and only one I thought of, the only one to whom I could entrust the delicate work of the set and the costumes for Jean Cocteau, this incarnation of style, this protean being who was the embodiment of all trends—Proustian, avant-garde, Dadaist, surrealist, and neoclassical. Vincent created wonders. It was a film with no money. It was driven by imagination, knowledge, boldness, and love.

The film was astonishing, dazzling, and we were selected for the Cannes Film Festival. Oh! Vincent, dear Vincent, my Vincent, how I thank you, and oh, how I love you!

Once upon a Time at the Ritz

I have one flaw that in others is a quality: I am passionate about my ideas, and I see no limits.

The day François Tajan approached me with the idea of a sale of the Ritz's furniture, he explained, with his hallmark elegance and honesty, that the furniture he wanted me to stage would usually still be in place, in the hotel itself. In this case, though, this was difficult, if not impossible, because the legendary hotel had been renovated two years previously.

The idea was to create the impression that, on entering the Hôtel Dassault, the buyers were in the enchanted setting of the Place Vendôme. I was led on a tour of the warehouses, filled with furniture and objects, like an abandoned lot for *Citizen Kane*, where furnishings, in their infinite accumulation, lose their charm: beds, tables, armchairs, sofas in matching sets. The project's unimaginable scale made me dizzy and a little uneasy.

I asked for photos of each of the items in the catalog. Faced with this interminable list—ten thousand lots—I began to cut out each image, creating an enormous collage, furnishing the suites, salons, and rooms with maniacal precision. Once the work was done, I drew twenty maquettes, each representing my imagined Ritz, transforming the entire Hôtel Dassault into a hotel where each floor reflected a past reality.

Visitors were welcomed by torchlight on the forecourt; the hotel's lobby was draped in blue curtains, leading to the reception desk, then the Bar Vendôme with its furnishings, and the conservatory, with its fountains and statues. On the second floor, following the surprise of the ceremonial reception and the gigantic bouquet by Thierry Féret, you entered the grand salon, where the gilded Louis XVI furniture shone on an Aubusson carpet. The suites followed one after another: Coco Chanel, the Duke and Duchess of Windsor, F. Scott Fitzgerald, and finally the Imperial suite, for which I had created panoramic wallpapers that were realized by Au Fil des Couleurs—a trompe-l'oeil design of baroque paneling in various colors.

The Ritz's different phases unfurled like the set of a musical, with undulating curtains and canopies. The final room was a historic bathroom, furnished with all the archetypes of this legendary place, including the hotel's first bathtub, dating from 1880, in the center. More historic furniture could be found in the Chinese salon, a creation, like the Tapestry salon, from my own imagination.

On the third floor were the simpler rooms, Proustian evocations: floral wallpaper, matching curtains, brass beds, dressing tables, and trinkets. Visitors then crossed the gallery of windows leading to the famous Bar Hemingway.

When I presented the project to François Tajan and his team, they couldn't believe it: they had expected a simple decoration, not a sophisticated project. Each object was catalogued and displayed: the challenge was to show all the categories of each piece so that buyers were able to see all of them.

The three days of installation were feverish, bordering on hysteria, especially as television cameras were constantly following us!

Success was my reward!

Charles of the Ritz

ARTCURIAL BECOMES THE RITZ

Paris in Spring

BAR VENDÔME

Chavirant

elle choisit toujours

THE GRAND SALON

"C'est ça le cinéma !"

THE RECEPTION HALL

Une minute !...

ou l'histoire de l'en...

UNE NOUVELLE INÉDITE DE BUDD SCHULBERG

une Nuit loin du Monde

THE WINDSOR SUITE

THE F. SCOTT FITZGERALD SUITE

La célèbre Cafetière Melior

THE IMPERIAL SUITE

La Duchesse Ardente

COCO CHANEL'S SUITE

Bas Bleu

MARCEL PROUST'S BEDROOM

ARLETTY'S BEDROOM

Beauty-Flash

CHARLIE CHAPLIN'S BEDROOM

Qu'en pensez vous !

IL TRAVAILLE bien et en silence !

THE HISTORIC BATHROOM

THE TEAROOM

BHL: Hôtel Europe

I was very touched when Bernard-Henri Lévy asked me to design the set for his *Looking for Europe*. Writers are the people who intimidate me the most! When I was young, I was very impressed by my uncle, Jorge Semprún, and I still remember our lunches together, from which I would leave flustered, wondering what such an amazing thinker and intellectual could find in my conversation.

I had been fascinated for some time by Bernard-Henri's global causes, and so I was immediately captivated when he explained his project on the fragility of Europe today. This philosopher, in effect, would cross the continent to explain his thinking, going on stage each night to give a breathtaking performance, and every day modifying the text in light of the events in the country concerned. It was a courageous and remarkable adventure for this human rights crusader.

I felt the weight of the responsibility; I was afraid of endangering this daring project, and at the same time, I was extremely honored to be part of it. The staging of this topical event could not be affected by decorative mannerism in any way.

Starting from a blank sheet, my mind instantly went to German expressionist cinema, which also spoke of the tragedy of its era. I stuck with the cubist aesthetic, black and white the obvious choice. The lack of budget, and the fact that the sets had to folded and packed to travel with ease around the globe, were exciting constraints, because they form a base and allow the imagination to take hold. So, I designed covers that would go over the chair, armchair, bathtub, and desk in this fictitious Sarajevo hotel room where Bernard-Henri Lévy would appear to be preparing his speech for the next day.

The course of the play was accompanied by the projection of this room which—as the worries and anxieties of the author grew, trapped in the difficulties of writing his text—transformed, vacillating in its perspectives, and oppressive negative spaces, like *The Cabinet of Dr. Caligari*. Visions interspersed with videos, along with music by Nicolas Ker, gave rhythm to the author's long monologue. The stark simplicity did not take anything from the importance of the words, and I believe that I respected and supported the text.

BHL'S EXTRAORDINARY PERFORMANCE

LE SEMAINIER SCANDALE

elle a mauvais caractère
elle déteste ma famille
elle est désordonnée
elle dépense trop
elle prétend me transformer
elle ne me laisse aucune liberté
elle n'est pas femme

Quadrille

In a private passage, just below Pigalle, I often passed a marvelous figure walking down the cobbled street, surrounded by fluttering pigeons. She wore white trousers and a well-cut pea coat, coke-bottle glasses, and her shining footwear rang out on the ground like tuning forks.

This silhouette, pure elegance, without fear or arrogance, moved swiftly and nonchalantly toward a future that was then unknown to me.

I had no idea she was a famous actress, one who made the whole of France laugh. I saw only the perfect aesthetic, an image of the past in black-and-white snaps, somewhere between Maria Callas and Jackie O. Then we became friends and, behind the glasses, I discovered Valérie Lemercier, gentle, fun, and wonderful. I went to her fabulous shows. We exchanged friends and laughter! Daniel Toscan du Plantier asked her to direct and perform in the remake of Sacha Guitry's *Quadrille*. For the sets, Bertrand Burgalat, who was part of the group, first thought of David Rochline, an eccentric aesthete who lived in a facsimile of the 1940s. Valérie recognized that the look of this film was incredibly important—it was her first film—so she decided on Pierre Le-Tan, to whom I had introduced her. There could be no one better than the designer of the loveliest covers for Patrick Modiano, and a collector of Bérard and Cocteau before it was cool, to reinterpret those bygone years through a nostalgic lens of pastel shades.

And so, Valérie entrusted the sets to him, the costumes to me, and the music to Bertrand Burgalat. I remember the meetings in my living room, accompanied by cups of tea. Valérie laughed at my pyramids of fruit, and we reinvented this *Quadrille*—Pierre and his paintbrushes in the film studios, me during fittings at my faithful Atelier Caraco, creating bias-cut dresses for Valérie and Sandrine Kiberlain. I asked Pierre to design the prints for the fabric, while the men were dressed from a tailor's on the Rue du Mont-Thabor.

André Dussollier was much amused to rediscover the Prince of Wales check fabric. The film was a fun adventure; friendship mixed with work, all focused on creation, to give the audience the feeling they had entered a drawing. Valérie's perfectionism and attention to detail would lead to her later supervising all the sets for her films. Her curiosity is boundless—it was she who introduced me to Svenskt Tenn fabrics, and in each of her films, I can see her keen eye.

Réveillez la Couleur

EN CHERCHANT DANS MES PLACARDS

DES COSTUMES POUR LE FILM

miraculeusemen

IN VALÉRIE'S FIRST FILM, WE IMAGINED A MULTICOLORED SACHA GUITRY

AMOUR

JE REDECOUVRE DES MANNEQUINS DE BOIS SUR

LESQUELS J'AVAIS DRAPÉ DU PAPIER CREPON

COMMENT TROUVER UN MARI...ET LE GARDER

COURRIER du CŒUR

LA ROSE DES VENTS

trompée"

I MADE
ALL THE COSTUMES
IN ATELIER CARACO

CE SONT LES SILHOUETTES DES COSTUMES DE QUADRILLE LE FILM DE VALÉRIE LEMERCIER

Il EST 5 HEURE?

QUADRILLE

Vive le grand air !

toutes les couleurs chantent

PIERRE LE-TAN'S
SETS MADE THE COVER
OF *WORLD OF INTERIORS*

QUADRILLE

VALERIE SABATIER

sa robe rêvée : ligne simple

VALERIE LEMERCIER

Talking to you about Vincent—"Vichnou" as I call him sometimes, although sometimes it's just "Viche," to save time—means starting at the beginning. The beginning of him in my life, in any case; it was only later that I discovered the beginning in his life—or his lives, I should say. I have the impression that he has already had several, and that, thinking about it now, that's probably why I call him Vichnou, like the Hindu god with many arms. Viche, whose many arms stretch out to us all. Because we are many. And yet, when he is with you, it always seems as if he is only yours.

It's more than twenty-five years since we first met, but I remember it perfectly.

At the time, we were just neighbors, in Pigalle's small Avenue Frochot. I used to see him walking in the evening, together with his friend, as a couple. One day he rang my doorbell: "My friend died yesterday. I don't know why I wanted to tell you." I went to Akis's funeral at the Orthodox church on Rue Daru; I went to kiss Vincent, to tell him that now, if he wanted, we would be friends. And that is what happened.

Everything is mixed together. Friendship, summers, work, meetings, impromptu visits, dancing, especially in the clubs. I didn't know him during the decadence of the Palace era. I watched Vincent glide quietly from fashion to decoration, becoming happier and happier.

Since childhood, Vichnou's life has been theatrical, so his presence in theaters, where I was dying to begin a new show, was never intrusive.

Even before we started, Vincent's laughter made the fear disappear, made things possible, normal even.

For *Quadrille*, my very first film (as director), it was only natural that I would ask him to design the costumes. He gave me the idea of entrusting the sets to Pierre Le-Tan, who he also asked to design the textiles. We mixed it up.

Thanks to the two of them, it was no longer a question of re-enactment. Bertrand Burgalat took care of the music. The four of us were "making a dream," following faithfully the worlds of Sacha Guitry, but mostly, we were having fun. Usual film-set hierarchy is often stifling, but here everything was invented, designed, the fabrics were dyed, the embroidery made to measure: everything was possible.

I remember a vacation in Italy, where he had taken all his dearests (including me) to escape the furnace of Paris, with a kitty for food, cigarettes, but not pharmaceuticals!

Vincent isn't as you'd imagine, watching *Death in Venice* on a loop each night. He loves *Porn in the Hood* and *Pattaya*, and it is thanks to him that I discovered these hilarious comedies. He goes to the cinema probably more often than most actors I know.

Creating dreams from nothing, making do with what's there, he also knows how to stage objects for sale poetically, from the Ritz, or those forgotten in the basements of the Musée des Arts Décoratifs in Paris. Make a summer mattress for Monoprix and the cover of the prestigious *The World of Interiors*, simultaneously popular and experimental. His shift from fashion to decoration has transformed our prince into a king.

Never bitter, always happy for the success of others, always eager to discover new actors, stylists, filmmakers, authors, and above all, to bring them all together.

More than anything, Vincent is a child who never grew up. A child never so happy as to not have to go to school, to stay all day in his pajamas, with his pencils and his dreams of a happier, crazier, more fabulous world than the real one. To make us happier. A child who is amazed to find something or someone "jeuli" no matter where. Because for Vincent, nothing is "joli" (pretty); it is always "jeuli", that is so *jeuli*!

As a person, Vichnou is always light, but sometimes he can be quite, quite heavy. I was lucky enough to carry the cabin bag he was taking for a weekend break. Eight pairs of shoes and their wooden shoe trees, each weighing over three pounds. Twenty-five pounds of shoes to be carried nonchalantly, to hoist into the plane's overhead locker, and to finally spend two days in sneakers.

Vincent, I'd love to see you more, to laugh as we've laughed, drunk on the wind, on the tiny Swedish island of Sandhamn, in that hotel for sailing enthusiasts, where I made you believe I had an enormous room, where you stage managed our dismay, making us all come out of the restroom onto that unlikely dance floor. That time, our suitcases were filled with shorts, bathing suits, and flip-flops, when what we needed were boots and oilskins. The next day, the weather was mild, and we walked through a birch forest. For me at least, it was the first time that a walk like that wasn't a chore.

We were *jeuli*, and thanks to you, we believed it.

Gallery Installation

As I consider my job as an exercise in styling the decorative arts, I'm always humbled when galleries call on me. My friend Mauro Nicoletti, my Italian brother, who I met in Rome when I was working for the Fendis, asked me a few years later, in 2016, to create a new performance for his gallery during the FIAC, the international contemporary art fair held every October in Paris. He asked me to make a selection from the works he had, both contemporary and older. On discovering the artists' works, I suggested paying tribute to Arte Povera, creating an abandoned studio whose decrepit walls would reveal their construction.

A concrete table, the works laid out with no plan—any old how—vestiges of a neglected past, forgotten in this decadent room. The rough concrete floor of the Grand Palais hosted this selection, a deceptively random accumulation to render a brutal vision in dilapidation.

Looking at the installation in the days before the FIAC opened and discovering the other stands alongside us, I began to panic: wasn't I putting the artists and my gallerist friend in danger?

The result though, was a complete surprise, and the FIAC officials deemed it the most interesting stand of the year. Mauro still talks to me about it!

The challenge for Aline Chastel, whose gallery specializes in Serge Roche and Line Vautrin, was quite different. She wanted to update the very precise style, of which she was both one of the pioneers and the benchmark, for an exhibition of 1960s Brazilian furniture. She asked me to transform her gallery on Rue Bonaparte for the show. I often say it, but it's true, that I work with the unconscious: from the pencil to the paper, instinctively abstract and colored forms appear from my hand, with no exact reference, just the image of the furniture in my head.

The flat colors created a new geometric perspective. Aline, on seeing the maquette, exclaimed that it looked a lot like the work of Brazilian artists from the era. I was happy and pleased, because chance always guides my steps.

To complete the work, I asked Raphaël Schmitt, a cheerful friend just out of the Van Der Kelen school in Brussels. He threw himself into this difficult project in August, in the middle of a heat wave, alone in the gallery, following my somewhat sadistic orders. His worry at not being up to the challenge amused me. He did the frescoes brilliantly, with the help of Aline, who was far nicer than me! In September, at the opening, the extraordinary change in the gallery left everyone stunned. No one imagined they would find my taste in such company!

Long-standing friend Pierre Passebon and I have done several exhibitions together. I love his eclectic taste, the way he mixes the artists and decorative arts of the twentieth century. He has a very particular eye and along with it, an unconventional humor. He wastes no time making decisions: when I told him that I'd created the Insomniac Collection in Rome with Mauro, a delirium of surreal objects straight out of my dreams, made in the workshops of Pietro Arco Franchetti, he instantly offered to show it in the Galerie du Passage in Paris. Our understanding, our shared lightheartedness, meant that this last-minute exhibition, the first vernissage of the post-confinement world, turned out to be a success!

GALLERY INSTALLATION

A FRESCO
BY RAPHAËL

GALERIE CHASTEL MARECHAL

CALDAS
HAUNER
EISLER
RODRIGUES
SAPINELLI
TENREIRO
ZALSZUPIN

L'OGRE

THE HOMAGE TO ARTE POVERA AT FIAC 2016

TEMPS D'ARGENT

MY FRIEND MAURO NICOLETTI'S GALLERY, MAGAZZINO

je n'ai plus rien à me mettre !..

ATELIER ABANDONNE CURATED BY VINCENT DARRÉ

GALERIE DU PASSAGE

SOMNIAC COLLECTION

VINCENT DARRÉ

THE INSOMNIAC COLLECTION STARTED OUT IN MY GARDEN AND ENDED UP IN GALERIE DU PASSAGE

Fashion:
The Show Must Go On

When I worked in fashion, I was always imagining scenarios. In decoration, I continue to work like this. I use a cinematographic process that acts as a framework for every new project. Several times in my career, I've worked with photographers, drawing them into my delirium. One summer, I embarked on such an adventure with my friends the Silvagnis. It was August and Arletty had just died, and I was building and painting sets, taking down curtains and making dresses. This summer improvisation became a job in the fall. Brigitte Langevin, then editor-in-chief of *Glamour* magazine, asked me to recreate this performance for a fashion series, this time using models.

It was a delight to have the leisure to choose clothes from the couturiers, like theater costumes. Without a care, François Halard and I set off on this adventure, which was repeated in another series, a tribute to Juliet Man Ray. For this shoot, I made totems and sculptures from objects found discarded at a dump. Then Pierre Bergé asked us to do an ad for Yves Saint Laurent. I immediately thought of a tribute to Jean Cocteau—Pierre held the moral rights to his work—painting large old doors in black and white to recreate the allegories of *Testament of Orpheus*.

One day, to my great surprise, my friend Jenny Capitain, who had become editor-in-chief of *Vogue Paris*, asked me to do the same for her magazine: sets and costumes, but this time I was the photographer, which I did without knowing anything about the job! As always, I took up the challenge with abandon. I did a haute couture shoot, referencing Russian ballet, where I asked the models to pose as if in they were choreographed, placed between giant hangings I had painted. There was also a nod to Edith Sitwell for a special issue overseen by Gianfranco Ferré, with the baroque opulence of clothing in the abandoned decadence of a disused factory where eighteenth-century tapestries were enshrined.

My photography career soon came to an end, and I returned to work as a designer in Italy, but I often like to find such collusion with the photographer. With Olivier Zahm, for *L'Officiel*, we created a tribute to *Funny Face*, with Lily McMenamy taking Audrey Hepburn's role and Valérie Lemercier that of Diana Vreeland. I painted backdrops that referenced Vincente Minnelli's musicals.

I am always as excited as a child when I get to spend the day dressing up models and directing.

FASHION THE SHOW MUST GO ON

68-62.

Oh!

VOGUE VOGUE
VOGUE VOGUE

L'Italie à l'Anglaise

excentriques

JENNY CAPITAIN ASKED ME TO BE A PHOTOGRAPHER FOR *VOGUE PARIS*

Entrée des Artistes

Carrosse d'Or

Quand la Haute Couture sort de ses cadres, égéries des Ballets russes et courtisans Renaissance se retrouvent le temps d'un bal

HAUTE COUTURE SERIES FOR *VOGUE PARIS*

...cependant

DU SEX-APPEAL DANS LA CHEVELURE

COMME J'ADMIRE LES REFLETS DE VOTRE CHEVELURE

I PAINTED ALL THE SETS AND DESIGNED THE POSES

la qualité est inchangée les prix sont les mêmes

SOLEIL PLEIN AIR

Dʳ N. G. Payot

Cadeaux **EXQUIS**. À l'avant-garde de Noël, des objets

d'artistes pour fêter quelques notes d'amour sur un air surréaliste.

I PHOTOGRAPHED ARTISTS' GIFTS FOR THE CHRISTMAS ISSUE OF *VOGUE PARIS*

Si les hommes savaient...

POLAROIDS BY FRANÇOIS HALARD

EXCENTRICS FOR
GLAMOUR MAGAZINE

femme d'affaires le jour,

femme du monde le soir"

le rouge-baiser
permet le baiser

DRAGA la bien aimée, Reine tragique

FRANÇOIS HALARD'S
TRIBUTE TO JULIET MAN RAY

CRÈME ÉCLIPSE

SETS THAT I PAINTED

Oui, C'EST LE MÊME CORSELET →

LA LEÇON DE MODE 58-59

OLIVIER ZAHM
FUNNY FACE

Allo, Allo! Ne coupez pas:
Nouvelle longueur: 6 centimètres

VALÉRIE LEMERCIER
& LILY MCMENAMY

FUNNY

FACE

Ne coupez pas la cuticule!

miraculeusement

MAX FARAGO PHOTOGRAPHED
MY STAGING OF AMIRA
IN THE BEAUX-ARTS CHAPEL

LA VOIX HUMAINE

toutes les couleurs chantent

que dois-je faire?

AMIRA CASAR

I remember you, Vincent: gorgeous and tanned, golden skin, lightly curled hair, reminiscent of a young Pasolini, at the Blumarine runway show, where you designed the collection with a very small, somewhat eccentric woman covered in flashy diamonds; then at Moschino. I remember our first meeting in Milan, backstage during the fashion shows; I was a young woman, a miniature model swimming against the tide, lost in the midst of these beautiful, magnificent giants, whose clothes were all fitted to their exaggerated heights. I was struck by our meeting: it was a moment, you saw me, we saw each other in all the Italian chaos, the general hubbub, and, from afar, you watched me, amused, because nothing was my size. Then you came to my rescue with your legendary generosity and unmistakable sense of humor. You undoubtedly had a smile on your face because of the absurd shoes that were so big on my feet, ridiculous boat shoes fit for a disenchanted clown. We got to know each other between cascades of laughter; then together, in record time, we stuffed the shoes with plastic before I went on stage. I instantly loved the intensity of that moment, of you, the guardian of my secret—I confided that I had always wanted to be an actor. You encouraged me always. You understand that we, actors, are multiple and dream of manifold, amplified lives, that we are asocial. That we play the gods of Olympus, that we are monsters, that we don't love enough, or at least, well enough.

For a while, life and destiny separated us, and we lost sight of each other. Then one day, after I'd left the Conservatoire d'Art Dramatique, while I was on vacation, we met again, at the Port of Tangier. It seemed, in the dignity of your silence, that you had gone through insurmountable trials, burnt by the bright sun of Africa. And always your sunny smile and the capacity to reinvent yourself, that's your strategy. I saw you again in Paris; you'd called me a few weeks later to tell me, with a choking voice, that your (intimate) partner, Akis, had just died. You came to live next door, and we had pajama parties in the tiny Chinese guest bed where we had to sleep at an angle, with our feet dangling over the edge. The Chinese bed that I inaugurated, which later welcomed so many wandering sisters to your baroque apartment. Your love of cinema amazed me: we watched so many old Italian films together. You worked with Karl Lagerfeld and had so many fabulous stories.

I loved to see you skirting the forbidden, living on the edge, smoking cigarette after cigarette in the sun, resisting the interdictions of the health police—red meat, wine, pollution, on the gray, dull café terraces.

For me, you are the embodiment of the multidisciplinary artist. You remind me of Cocteau, a versatile magician, conjuring the fantastic, the joyful, and the tragic: sometimes it is ceramics, sometimes a theater set, sometimes costumes for the opera, sometimes photographing me as a nun from a Buñuel film, or as a neo–Anna Magnani, or you as the artistic director of *Vogue Italia*; crazy projects, drawing on the beautiful and the fantastic. Because with you, my dear friend, brother, cousin, more than all that, Vincent, life is a folly better outside the family, forever enhanced.

Your apparent lightness complements to your depths.

Palazzo Durini

I often think of Franca Sozzani, the Madonna of Italian fashion, subtly drawn by her presence and her clothes, which saved her from stares during her illness, which she faced with courage, hating the lamentations that were her usual lifeline.

I've never met such a powerful and spiritual woman. When I told her of my idea to take part in the Milan Furniture Fair, she supported me without hesitation. Another Italian friend opened his palace to me. Painter and philanthropist Giulio Durini, descended from an old bohemian family, had just taken over the Fondazione Durini, created by his great-great uncle, who shared his taste for men.

Giulio had first welcomed me to the palace when I was designing for Moschino. We slept in a decadent apartment amidst the rubble. Years later, I returned with my Cadavres Exquis collection, which included lacquer tables with cubist figures, similarly inspired carpets in a bold range of colors, and a wallpaper made from my collages.

The installation was in sharp contrast to the palace, recently restored in good Milanese taste. Film spotlights lit up this Franco-Italian vision that summarized my bilingual life, though to spice it up, I included a piece dedicated to the blog that I had at the time with Marine Prud'hon: *Vincent Darré, Pourquoi ?*

This encapsulation of my adventures of today and yesterday much amused Franca when she discovered a photo of Christian Louboutin and me in the late 1980s.

"Très Sport"

IN THE PALACE
OF MY FRIEND
GIULIO DURINI

INSTALLATION

APRIL 19th 2012 AT 6:30 PM

CASA VOGUE

PRESENTS

VINCENT DARRÉ

FONDAZIONE DUPINI

for this HIT SHOW?

CADAVRE EXQUIS

SAVE THE DATE

VIA SANTA MARIA VALLE 2, MILANO

PLEASE CONFIRM YOUR PRESENCE TO
events@emanuelaschmeidler.com
0039 0263679900

Brillantine LUSTRALE

VERALINE
ENDUIT PLASTIQUE AUX SILICONES
GARANTIE TOTALE

Luxury Living

When I worked for Fendi, I was in charge of most of the licensing. Fendi Casa was Anna Fendi's department, and with her legendary gentleness and tenacity, we had a lot of fun. With the Fendi family, between Karl Lagerfeld and those hilarious Romans, the banter and the laughter soared. I think this was the time I had the most fun working. So it was again by chance that I crossed paths with Alix de Chabot. She called to ask me to create the set design for Luxury Living Avenue Montaigne as part of Design Week.

I love using green in decorating, even more so since Adriana Asti, on seeing a sofa covered in green, told me that the lovely Luchino Visconti adored seats covered in the same shade, which later came to be called Verde Visconti. I realized that this was, without doubt, the family's favorite color! I chose the palette when I visited the palace and decided to transform it into a magical garden, covering some of the house's iconic rooms in a range of greens and designing a panoramic wallpaper of caryatids supporting trellis arches, like from the fairy tale *Beauty and the Beast*. I'd found the title of the installation! I went hunting in the incredible studios of the national museums, on the lookout for white plaster casts, horses' heads, giant hands, incomplete busts, and angels' wings to give the whole a phantasmagorical touch. We moved around ivy-colored still lifes as they appeared in Jean Cocteau's film, but the beast was missing! In search of wonder, I found, at Design et Nature, the taxidermist on Rue d'Aboukir, rabbits holding watches or juggling, just like in *Alice in Wonderland*, and crowned lions who roared. For the final touch: a canopy made from a Pierre Le-Tan print welcomed the imaginary Beauty—all that was left was to open the gates of this extraordinary garden.

LE
FANTOME
DE L'AMOUR

A SCENOGRAPHIC TRIBUTE TO *BEAUTY AND THE BEAST*

Spoleto Festival

I've known Giorgio Ferrara and his wife, the actress Adriana Asti, for a very long time. They are my Italian family, wonderful and protective friends. I've done everything with them, even acting in one of Giorgio's films, playing an eighteenth-century French chef with the great Franca Valeri. When the maestro became the director of the legendary Spoleto Festival, he naturally turned to me, asking me to make the costumes for the two operas by Silvia Colasanti: *Il Minotauro* and *Proserpine*.

I was given free rein to create lyrical costumes and had the chance to work with the Farani atelier, where the costumes for Pasolini's *Medea* and Fellini's *Casanova* had been made. It was like plunging into the memory of Italian cinema, from the greatest wig maker to the incredible milliner/armorer, Pieroni. For *Proserpine*, this artist made hats like circus tents, using cork to imitate metal, while seamstresses draped jersey in gold, copper, and silver, and for *Il Minotauro*, hung flights of satin, like angels flying free from frescoes.

For a week, I lived outside time in the small town of Spoleto, crossing the empty square, my only appointment the four hours of the opera's rehearsals. What a delight to listen to specially invented music, where everyone is part of a magical puzzle that will all come together at the premiere! The hours of listening to the singers—exquisite beings, touchingly modest demigods; the Minotaur, powerful and sexual; the diaphanous goddesses, the metallic reflections of Persephone—before the wonderful set of painter Sandro Chia, moved me every day. I adore the quiet waiting in the loges, hearing Giorgio get worked up, the singers starting again, then the sublime light. Lyricism is at its apogee, the curtain falls and rises again before the troupe: a singular joyful greeting, an immense fraternal bond.

FESTIVAL DE SPOLETO

Premier Chagrin d'Amour

GIORGIO FERRARA INVITED ME TO THE SPOLETO FESTIVAL

BRAVO, MADAME

PERSEPHONE AND HER CARYATID GODDESSES 2019

THE OPERA
IL MINOTAURO,
2018

que dois-je faire?

Let the Party Begin

Since the days of the Palace nightclub, I have always loved to party, and I'm also fascinated by long-forgotten balls. The legendary balls of the Beisteguis, of the Noailles, and of the Beaumonts haunted my nights with extraordinary apparitions.

That's why I'm always excited about doing the decorations for a party; I like to think about making a space dramatic, which I did several times at Maxim's with the help of my friend Pierre Pelegry.

Guests are invited to dream—my role is to lead them on an unexpected journey, an induction into oblivion, forgetting reality to embody a character for the evening.

During an evening for the magazine *L'Officiel*, in a restaurant on Rue Royale, I designed a clock to go back in time. Guests entered a room transformed with veils and torches, inspired by the corridor in Cocteau's *Beauty and the Beast*. They then passed into the first salon, a tribute to that of the Noailles, with 1920s furniture and paintings that were actually the covers of the magazine from the time. The dining room had become the celebrated cabaret Le Bœuf sur le Toit, where the tables were covered with cubist-inspired cloths. Climbing the stars, the era transformed, moving into Elsa Schiaparelli's salons, with ostriches and flamingos posing in front of *L'Officiel* covers from the 1940s. Continuing the ascent, going forward in time, we found a tribute to Gruau and his famous colored pencil sketches for fashion magazines, matched to the 1950s furniture. Passing through the doors of another salon, we were in the home of the Pompidous, when Georges was president and Pierre Paulin made over the Élysée Place, while the final space was a smoking room inspired by Serge Gainsbourg and the 1970s and '80s.

For three friends celebrating their birthday, I imagined Maxim's disguised as a Belle Époque brothel, where a baroque bathtub flirted with an animal orchestra.

My favorite décor, though, was a tribute to my surrealist god, Dalí, for Lancel. The house had just reissued a painting of his from the 1970s, *Daligramme*. I loved this launch: I locked a hip rock band in the storefront windows, the guests were greeted by two violin-playing bears, and they were announced in a tableau vivant inspired by the Spanish painter. A sofa like a pair of lips and Mae West's eyes watched everything, surrounded by metaphysical still lifes flying off into the clouds. Meanwhile, a corridor of telephones and butterflies introduced themselves to a white bear, the symbol of Cadaqués, with its crown and scepter.

Tables spread out under the parrot chandeliers, and giant fish and lobsters snacked on the house's bags. The curious could discover another dining room, framed by baroque mirrors and cascades of ivy. If they hadn't already lost their heads, here they tumbled into infinity.

For Kate Moss, I transformed the Ritz's swimming pool into an English castle where family portraits and leopard skins led to a pagan chapel where skeletons played guitar in front of religious artifacts. There were even prie-dieux for night owls to kneel upon!

avec **TABOU**

Quelles que soient la forme... la couleur... l'expression... de vos yeux... **ARCANCIL** les embellira.

FUMOIR

Les vitrines nuageuses, natures mortes surréalistes

**SURREALIST PARTY
SALVADOR DALÍ
FOR LANCEL**

air de paris

Scandale

Scandale

DALÍ'S BEAR IN CADAQUÉS

LA VIE PARISIENNE

KATE MOSS'S PARTY FOR FRED AT THE RITZ'S SWIMMING POOL

Dans le Tourbillon de la Danse...

mirages

DINNER AT THE MUSÉE DES ARTS DÉCORATIFS FOR THE MINISTRY OF CULTURE

BIRTHDAY PARTY AT MAXIM'S

ECHOS

L'OFFICIEL'S 90TH ANNIVERSARY

EVA IONESCO

Vincent and I have been friends since childhood, but it feels as if we've known each other forever—a golden, unchanging age.

The first time we met was on a beautiful summer's evening, scorching hot, in 1976. The blazing sun was melting into the rose-pink sky, announcing a blistering summer. I was only ten and a half, wearing a queen's crown and stilettos. and he, elegant, with a lock of hair falling over a mischievous eye, was sitting against the light of an open window. All of sudden, everyone else in the room looked asinine. Once they had melted away, only then did we say, "Bonjour."

We have since experienced so much together, traveled together, and had so many wonderful, and some ridiculous, moments, ones that I will never forget. They are fixed in my memory, no doubt to remember them better, like others maintain the habit of forever wearing the clothes of their youth. During our teenage years, that time made of odds and ends and immense, heart-breaking emotions, Vincent liked to search through flea markets. His rooms, where he reigned in a theatrical atmosphere, were decorated with chimeras, Greek friezes, a canopied bed, starfish, columns, Venetian mirrors, and theater masks, already displaying an exquisite, paradisiacal taste and a joy for life. I loved to watch this young man working, his back straight like a schoolboy, always impeccably dressed, drawing baroque dresses and decorations for imaginary balls, casting improbable spells—he who knew nothing about life but seemed used to everything.

He was extremely lovely, with a look of Louis Jourdan; when he walked by, heads would turn; he, so young and worshipped. Days would go by, and we had no end of fun improvising ephemeral happenings where he staged objects and themes, always joyful, always happy. One day, coming down from Pigalle, where the girls of the neighborhood were undressing in their barracks, performing a striptease to the rhythm of a song, Vincent found a trunk full of eighteenth-century-style costumes outside the Folies Bergère! What a windfall! Because, by the most wonderful of coincidences, Karl Lagerfeld's great Venetian Ball was to be held the next day at the Palace—from the city of the Doges to the city of the gods. He stole the trunk in the middle of the street, watched by the stunned eyes of the

curiously motionless passersby. Arriving in Rue Boulard, he summoned his friends in order to dress them up. I was not permitted anything of the treasure: he deemed my beautiful 1950 haute couture sea-green Nina Ricci—found at the flea market—enough for me. Bullied, I felt excluded from the game and I can still clearly see his face, lit up with the pleasure and malice of an enfant terrible.

In one of my Clairefontaine notebooks, I pasted one of his old drawings illustrating an interview for the Palace house magazine, captioned "I want to dress old women." Two women are talking, one wearing a skirt like an antique Pompeiian vase and the other, reminiscent of Gloria Swanson, wearing a Roman robe, and at the time we were listening to mambos. I think that the two first hand-painted terracotta sconces date to this Italian era, yet, on reflection, I love all of Vincent's periods, from punk until today.

Many years have flown by since that solar flare of summer 1976 and Vincent has succeeded in preserving the elixir, the innate gift of youth that reflects everything like pure crystal. When we grow up, this substance has an unfortunate tendency to diminish, but he knew how to cultivate it to better share his poetry. In my friend's work there are flashes of brilliance as the surrealists had, no doubt the result of objective chance, of an abundance of wonders.

Rendezvous with AD

One day, Marie Kalt appeared at my house on Rue de Bellechasse, scouting for the magazine AD. Her simplicity, sincerity, and refreshing enthusiasm were a welcome surprise. At the time, I was not yet an interior decorator; I was working for Karl Lagerfeld. Then, when I founded Maison Darré, she was one of the first to support and encourage me, asking me to be one of the interior designers for AD Intérieurs. I was especially honored to be accepted into this new family, as she officially called me a designer!

Every issue had a theme. The first was travel, so I devised a travel boudoir, thinking about those aristocrats who traveled from castle to castle, taking tapestries and furniture with them. My boudoir was built around an enormous lacquer and gold-leaf screen, the exquisite corpse of a wanton cocotte. A labyrinthine octagonal carpet, made by Codimat, framed the Conversation range of furnishings, which were making their first appearance. Pierre Passebon, who dropped by during the installation, lent me a statue of André Arbus and fabulous maquettes by Gio Ponti.

The second rendezvous with AD happened in a mansion on Quai de La Tournelle. Marie was quite surprised when I chose the smallest room: it had a high ceiling and two large windows—I felt comfortable there. Thus was born the little prince's room, with a four-poster bed, covered in a daring mix of six prints from my collection with Pierre Frey, three drawings based on three archival models from the 1940s. It was upholstered by the great Phelippeau and custom-made by Declercq, the whole illuminated by a Murano chandelier by my friend Aristide Najean.

The third encounter with AD took place at the Musée des Arts Décoratifs. While visiting their massive archives—reminiscent of *Citizen Kane*—I fell in love with the enormous wooden shipping crates, and so an idea was born: a tribute to the decorative arts, of custom-made furniture by the greatest artisans.

Stained-glass windows like cubist puddles, created by Atelier Simon-Marq, echoed the similar pattern on the Robert Four Aubusson tapestry covering the sofa seats.

Brazilian blue marble, an anachronistic response to the eighteenth-century wood-paneled mirror, faced an aluminum pipe by the sculptor César.

LES RDV DU AD

ENTRE-NOUS

THE TRAVEL BOUDOIR
AD 2012

CADORICIN

A LACQUER AND GOLD-LEAF SCREEN

La Maison DE Marie-Claire

MIXING MY PIERRE FREY COLLECTION

Une poupée!

NOËL EN IMPRIMÉS AVEC VINCENT DARRÉ

MAMAN QUI BOIT MON NIDO!

THE LITTLE PRINCE'S BEDROOM
AD 2013

A COLLABORATION
WITH FRANCE'S
GREATEST ARTISANS

Double Fil

Double Torsion

"Je ne fais que des bêtises!"

MUSÉE DES ARTS DÉCORATIFS
AD 2014

Poltrona Frau

I'd already met Goran Topalovitch and loved his energy and his enthusiasm. He told me, "One day we'll do something together." That day arrived. For Paris Design Week, the Poltrona Frau store on Rue du Bac was transformed into an imaginary theater, combining my work with the house's history.

I chose the iconic Vanity Fair chair as my focus, making a black-and-white film about its adventures, a homage to silent surrealist cinema, directed by my friend Charles Serruya, with Arielle Dombasle and Catherine Baba as guest stars. These two icons fell in love with the armchair and were pursued by a parrot hunter, the well-known Monsieur Lanzani of the renowned movie-prop rental shop, a space whose décor has become a labyrinth of varied objects, of corridors of furniture, a place of fantasies and dreams.

Original Poltrona Frau chairs furnished the screening room in the store where the film was shown. In the main room, elements from the set were mixed with prototypes of the famous chair, everything from its frame to the springs and upholstery. A giant sofa wound through the center of the room, designed specially, like a blue cloud on crutches, a tribute to Dalí.

A giraffe emerged from the ground and a rhino sat on a piano! The display windows were framed by cut-out caryatid silhouettes, creating theater stalls.

For visitors, the surprise was discovering our intertwined worlds, sparking a happening that led to another project, with the Bon Marché department store. Frédéric Bodenes, its artistic director, asked me to stage the collaboration between our two houses. Thus, I customized iconic pieces from Poltrona Frau to create a dialogue between the two worlds. Frédéric even asked me to do the windows for this exhibition, all the display windows along Rue de Sèvres. I imagined them like a film, based on the one I made for Paris Design Week. Each window would be an image on a roll of film, positive and negative. Passersby would discover my world like a miniature film set, while the actual film played on 1970s televisions.

The walls were covered with my wallpaper, white and black succeeding one another, creating a backdrop for my bestiary from the A l'Eau Dalí collection as well as the Poltrona Frau collaboration. Beneath the glass roof on the second floor, small furnished vignettes unfolded like a carousel of scenes, following the line of display cases: all different, slice-of-life visions, partitioned by a monumental lacquer screen. Visitors wandered through this timeless space, carried from one world to another.

UN FILM DE VINCENT DARRÉ

SURREALIST INSTALLATION FOR DESIGN WEEK

Un baiser de laine sur votre peau

DÉFENSE DE SORTIR SANS

LA MUSE EN CAGE
ARIELLE DOMBASLE

L'INHUMAINE
AU TÉLÉPHONE
CATHERINE BABA

"Et hop !"

Voici comment et pourquoi fonctionne la "Chaine Magique"

A la mode A"

UNDER THE BON MARCHÉ'S GLASS ROOF

Simone Baron vous dit :

SALON À CIEL OUVERT

L'ENDROIT LE PLUS

Le dernier rouge de Paris

LIKE A FILM, THE WINDOWS OF THE BON MARCHÉ

DE FRANCE

FENÊTRES SUR RUE

Qu'importe!

The Prince de Galles

Chance meetings are the driving force behind my work. Each of these encounters is like a key that opens an unexpected door, as was the case with Xavier Brunet, who was the press officer for Maxim's at the time. He offered to host a party for Isabelle Adjani and for me, a party that I will never forget, a blending of cinema and fashion for one fantastical night.

Isabelle, completely wild, danced till dawn. The invitation said: it's a party, not a wedding, not a birthday, but a party to party! Xavier suggested I repeat the night, this time with Kristin Scott Thomas, who was surprised to find herself cast in the role of party girl!

One day, Xavier reappeared, to open the doors of the great Parisian luxury hotel, the Prince de Galles. This hotel, with its 1920s architecture, is home to a wonderful mosaic patio, which I redesigned with a wave of my magic wand, returning it to the luxury of yesteryear. I had just finished a collaboration with Pierre Frey, and we decided to stay with restrained hues and opted for an imagined architecture print, in negative and positive, for the fabric, which covered all the seating. I designed the consoles and tables in wood to host lunch and dinner in a warm atmosphere, adding lamps with straw shades, creating and covering the patio's structure with ivy to complement the large palm trees, planted like nails in the courtyard's center. To heighten the effect, I placed a labyrinthine carpet that echoed the idea of a pool. My partner in this adventure, Xavier Barroux, had the idea of a pop-up bar in the hotel, and so added another element to this madness.

The installation was the day before the opening. My guests, the whole group, were extraordinary, and respected the invitation with their eccentric ways. Paquita Paquin, standing on an armchair, whistled at the D.J. Ingrid Caven swirled with Simon Liberati and Jean-Jacques was too drunk to go to the toilet downstairs and preferred going up and peeing in the corridor. I sang and danced on the tables, waking those who were napping. The revolution of luxury!

Security interrupted the scandal: they asked me to leave this wonderful place. Imagine the thrill of getting kicked out of your own party!

PRINCE DE GALLES

39 PRINCE DE GALLES

DESIGN FOR THE PRINCE DE GALLES'S PATIO

PARIS first...
then...
THE FRENCH RIVIERA

IMPROVISING WITH ISABELLE AT A PARTY AT CASTELS

A RIOT: DISGUISING ADJANI AS A PRINCESS

ISABELLE ADJANI

PHOTOGRAPHE
KATERINA JEBB

RÉALISATION
VINCENT DARRÉ

TEXTE
PHILIPPE AZOURY

ISABELLE ADJANI

Charles Trenet used to say that we should train for happiness as if it were a sport: in this discipline, Vincent Darré is a champion in every category.

Vincent is an enchanter, a Merlin of the art of living and of the decorative arts, who calls upon all the opposing forces of beauty and good taste to create new worlds where he sometimes loses himself.

He's a little crazy, a little mad, like me, unafraid of breaking rules, of shattering icons to create, beyond the realms of good and evil, heavenly gardens, filled with characters from Hieronymus Bosch's *Garden of Earthly Delights* or Tim Burton's films; madcap goblins who, like him, sow havoc and joy in the dusty interior of ennui.

When he sees a mermaid, Ulysses appears, tied to the mast of his boat. He lingers on details, the ropes which hold back the one who does not want to succumb to the torture of pleasure; these ropes that in a flash evoke the art of bondage, the cords of S&M. In no time, he swathes the young woman in waves of leather straps and a corset. In both costume and design, Vincent is a corsair of style, plundering the shores of heaven, of purgatory, and even of hell.

Despite all this, he is an angel, a real one, an angel who watches over you, a faithful angel who whispers, in the words of Charles Trenet, "Y'a d'la joie"—there's joy—whenever you feel down.

He knows both the taste and the price of tears, the cliffs of pain on which the skiffs of his imagination sometimes shatter. A builder of dreams, he never gives up. With the debris of a boat, he builds a frigate: that is his magic, the weight of his lightness.

He has been there, and he will be there again, as elusive as the weasel, the real one, not the one in the nursery rhyme—he is alive, sparkling, evanescent, sharp, and incredibly kind.

When he loves, he loves, with no fuss, no baggage, no regrets, no rancor. It is rare to do all these things at the same time.

A child of the Renaissance and the baroque—few are born of the tectonic shifts of these two ostensibly opposing eras.

He should have been the one charged with designing a new spire for Notre-Dame: the cathedral would have soared, crazy ... it would have been Darréd!

Holiday Homework

Because I always have a tan, people think I'm always on vacation, but I keep it just because it puts me in a good mood; I maintain my sun-kissed complexion on café terraces!

But I'm also someone who, perhaps in an old-fashioned way, likes to give the impression of idle elegance, which may be why I'm considered a dandy. It's true that I find it vulgar when people talk about their work over dinner; ultimately, I think this is a fault, one I have fallen victim to. But getting back to vacation homework, it often happens that projects appear at the last minute, when the opening is timed for the summer vacation. Contrary to popular belief, I like to keep going, to persevere and stay on top of the work. It alleviates my guilt about taking it easy.

One day, just as I was about to close my suitcase, Sarah Andelman called and asked me to be part of Les Vacances de Lulu, a curated selection at the concept store Colette, focused on my friend Lucien Pages. All I wanted was to be under a beach umbrella. And that became my stepping-off point for the theme: the stripes of beach umbrellas. I am crazy about the trompe-l'oeil of Charles de Beistegui's tents—with him, it's only a hop to the Venice Lido. My response was to design a wallpaper. My summer tent was furnished with my own objects as well as works by artist friends, including the gentle humor of cartoonist Antonio Pippolini. There was also the work of visual artist and painter Emel Kurhan, sister of my friend, Yazbukey: a painting of embroidered flowers mixed with painted images, with the floral work contrasting with the flat stripes. My young associate Pierre Chevalier had to return from his native Brittany for the installation, right in the middle of August.

Friends come into your life and turn it upside down with unexpected projects, as with Giorgio Pace. Before the summer vacation, he had suggested that I install a tent in the gardens of La Vigie in Monaco as part of the Nomad Design Fair that he organizes each year. I always prefer to share the workload, so I asked gallerist Jean-Pierre Jaïs of 18 Davies Street Gallery in London to go with me, bringing along his twentieth-century furniture to create a dialogue with mine. Beneath the striped tent, the sun did not, in fact, always shine. This was true for the last days, and a storm destroyed a piece of parchment furniture by Marc du Plantier! I was distraught!

Summer also has its joyful surprises, though. When, for example, the theater director Véronique Lopez called me, asking, in her authoritative voice, if I would be the ambassador of the Saint-Ouen flea market! How could I refuse? So, when the good weather returned, I happily trawled the flea market, going on an enormous treasure hunt. In each of the individual markets, from Serpette to Malassis, Vernaison to Paul-Bert, a hand-drawn banner brought together all the second-hand dealers. It was a way of thumbing my nose at the abandoned vacation, which ended so beautifully in this magical place that I consider my country home, walking the wisteria-lined avenues each weekend, weaving between Parisian antique dealers. I found myself having to defend this bastion of French heritage: the Saint-Ouen flea market, one of the five most visited places in France, was threatened by property developers!

I BECAME THE FLEA MARKET AMBASSADOR

des pas sur le sable

TOUT CET OR EST A PRENDRE

INVITATION FÊTE DES PUCES
PUCES MON TRÉSOR
MARCHÉ AUX PUCES DE PARIS SAINT-OUEN
LE JEUDI 19 SEPTEMBRE 2013 DE 19H À 23H

PUCES MON TRESOR
PAUL CAFÉ

Baume Solaire THO-RADIA — protection efficace contre les brûlures du Soleil

Le Maillot-Boléro

JE METS CE PATRON A MA TAILLE

NOMAD MONACO

LES VACANCES DE LULU AT COLETTE

D'heure en heure... Une journée de vacances

PARLER SEUL
TRISTAN DADA

The Biennale des Antiquaires

I am incredibly lucky to have several fairy godmothers who protect me, including Geneviève Hebey. From the moment she and her husband, Pierre, introduced me to Karl Lagerfeld until today, her magic wand has sprinkled sweetness and happiness over my life. In July 2019, just before the summer vacation, she called me:

– "You can do the décor for the Biennale des Antiquaires," she said.
– "But Geneviève, that's in September!"
– "Yes, but with your talent, you'll find a way. You'll have lunch with my friend Mathias Ary Jan tomorrow, and he'll explain everything."

We met in a big Parisian hotel, and as soon as I was seated at the table, he told me, "I don't know if you should accept this project. Everyone hates me! Expect to be criticized." This introduction immediately attracted me. I replied, "I have an idea and if it works, I'll do it."

My idea was based on the fantastical perspectives of the Grand Palais, but I needed objects that were out of proportion, in order to inhabit this gigantic space.

Rome, home of de Chirico, was the solution! Cinecittà and the antique sets of the Italian epics!

My vacation began in those studios, choosing monumental sculptures from the poetic, half-abandoned plaster workshops of the De Angelis family. In a deserted Cinecittà, Roman heads appeared, along with giant hands covered with ivy, capitals and columns, and pieces of ancient ruins.

At the same time, my knight, Pierre, was overseeing the execution of two oversized paintings, twenty-six by thirteen feet, made by Atelier Mériguet-Carrère from my drawings, an exhaustive metaphysical tribute. Returning from vacation was quite unbelievable, between the arrival of the truck in front of the Grand Palais and the surprise of finding ourselves left, with Mélodie Vasseur and Pierre, to carry the papier-mâché colossi on our backs. We also had to decorate our stand, and, at the last minute, I had the idea of covering it with burlap, leaving the concrete floor untouched, like a little abandoned theater. The veiled light of the linen on the Bocca della Verità on the ground attracted all eyes to the least expensive of all the stands at the Biennale!

Questo giardino

A GIANT PAINTING CREATED BY MÉRIGUET-CARRÈRE

METAPHYSICAL DÉCOR AT THE GRAND PALAIS

OUR STAND FOR THE 2019 BIENNALE DES ANTIQUAIRES

VADEMECUM

INTERMEZZO

BEAUTÉ SANTÉ BONHEUR

DÎNER DE GALA

Arielle on the Stage

Arielle Dombasle is one of the most fabulous people I know. When she suggests a new project—or rather, a new adventure—there is no way to say no. She could actually have her own comic book, *The Adventures of Arielle*, because there is nothing ordinary in any of her schemes.

The first, *La Belle et la Toute Petite Bête*, is a whimsical fairy tale directed by Jérôme Savary. Following the suggestions of a master fired up by Arielle's talent and character, I designed costumes in transparent plastic, inspired by Matthew Barney's exhibition at the Musée d'Art Moderne in Paris. Cellophane crinoline, a rose-crystal riding habit, a wicker and celluloid hat for this quirky princess, made like haute couture by Atelier Caraco.

For Jérôme Savary's extravagant *Don Quichotte contre l'Ange Bleu*, we used the same studio. The surreal scenario of this improbable meeting inspired me to create outrageous outfits for a Marlene Dietrich, including a riveted metallic corset, like the Tin Man in *The Wizard of Oz*! Even the hat was made of steel.

A succession of appearances by the diva: a Rolls-Royce, with a grille bustier, her own breasts the headlights illuminating her turn on the stage, and a chrome-red fan whose propeller sat on her curves and stirred the Spanish heat. The most absurd of all the costumes was that of the Dance of the Seven Veils: a silvered nickel corset finished with tap fittings and seven veils hanging from the shower above her head as she sang, "I don't understand why people find me odd!"

When Josée Dayan suggested she play Milady in another project, I told the director, who adores women, "Milady is the first S&M heroine, a female master, she will be dressed all in leather, right down to her underwear." What appeared, with the assistance of Claudine from Atelier Caraco, was a wardrobe made of skins for fetishistic musketeers: a Cordoba leather dress à la française, a green suede and leopard-skin hunting outfit, a saddle-stitched riding habit, a white openwork leather-lace negligee, and, for the royal ball, the jewel in the crown: a gold leather crinoline dress with a silver metallic corset and a trompe-l'oeil décolletage finished with a baroque mirrored frame from which the star's head emerged.

The puppets of the satirical *Guignols de l'Info* even wore copies of the outfits. My gamble had paid off! Though it is only Arielle who can wear the most incongruous, the most spectacular outfits with such natural grace.

I was surprised when she asked me to create the set and costumes for *La Traviata*, an open-air opera. We were both wary of falling into caricature. Arielle, who was directing, wanted to show the era's depravity and make it clear that Violetta, the Lady of the Camellias, was a victim of society. I thought about it, and who better than Grandville, the caricaturist of the era, to depict the spirit of the times. Women would be flowers, the men birds of prey. Thus, the fable unfurled like a midsummer night's dream, where the flora and the fauna were the protagonists. I was there for the rehearsals, and I saw the troupe's enthusiasm under Arielle's baton, drawing everyone into her customary madness.

ARIELLE TOUS EN SCENE

LA BELLE ET LA TOUTE PETITE BÊTE
BY JÉRÔME SAVARY

PLASTIC COSTUMES BY ATELIER CARACO

FEMME MODERNE

PLEINS PHARES SUR LA CHAMBORD

Il ne suffit pas d'être jolie pour être jolie.

DON QUICHOTTE CONTRE L'ANGE BLEU BY JÉRÔME SAVARY

DES PETITS RIENS QUI CHANGENT TOUT

MILADY DIRECTED BY JOSÉE DAYAN

SACHEZ TIRER PARTI *de* VOS PETITS ENNUIS

CHERCHEZ LA FEMME...

L'AMOUR N'EST PAS AVEUGLE

A LEATHER-CLAD S&M HEROINE

LES HOMMES

PREMIER ACTE
LES FLEURS ANIMÉES

**AN OPERA STAGED
BY ARIELLE DOMBASLE**

LES BOHÉMIENNES

La Chevelure de vos Rêves en

PREMIER ACTE

LA TRAVIATA IN THE OPEN AIR

Les Joueuses

PROMENADES

SETS AND COSTUMES, WITH A NOD TO GRANDVILLE'S ILLUSTRATIONS

PARISIENNES

LASTONE LES MATADORS

ARIELLE DOMBASLE

Vincent is, without doubt, my closest, my dearest friend. He is eternally young, a mischievous child, cherished from birth by a libertarian, feminist, and profoundly loving mother. He is a will-o'-the-wisp, who grew up free from the aura of a militant and communist uncle, climbing over the barricades and quickly freeing himself of all the "isms" to become a child of this century. He surfs the crests of fashion, design, poetry, and the creation of forms and of styles in an infinite outpouring that is always filled with mirth and curiosity, drunk on his own freedom, with his only masters the science of the beautiful and an unwavering talent.

Our friendship instantly crystallized around several essentials. We shared the same friends, the same joys, the same enthusiasm for beauty, the same taste for insolence, for the chic, the new, the funny, the couture houses and the wild fashion shows, for the aberrations of fashion, for the parties and whispered secrets.

Vincent's career sparkles. His uniqueness is a game of his own making. At the forefront of invention, his singular path metamorphoses worldly things into an imperial imaginary city, in stucco, columns, pilasters, and pediments, brilliant geometries with futuristic perspectives. Vincent is constantly navigating between surrealism and Dadaism, in a suspended world, enchanted by dreamlike citadels with Euclidean shapes, between two dreams of a classical golden age, with touches of the Renaissance. Always in that era's raging wake, Vincent is, as Rimbaud said, an "absolutely modern" being, that is to say, a rare being.

Our first true collaboration was around a revisited fairy tale that became a musical for the Opéra-Comique, *La Belle et la Toute Petite Bête*, where the fantastic director Jérôme Savary asked me to play Belle, who had to sing and dance on stage, accompanied by a symphony orchestra, in the rigorous tradition of true theater where, night after night, singers, dancers, and musicians perform live.

Knowing his talent and sensitivity, I asked Vincent to create the costumes for this idealized princess, in a fable where the craziest stories all come together. He, in turn, knew how to create the most wonderful dresses for me, inspired by Matthew Barney, in transparent Plexiglas on visible, flexible wicker frames covered with satin and crystals: pure magical enchantment.

The rehearsals were surreal and inspiring. Christian Louboutin made his first "glass" Cinderella shoes for me, all Swarovski crystals and heavenly curves.

It was a resounding success. We spent four months at the Opéra-Comique, playing to packed, enchanted rooms, and I was delighted to be this snow queen all in crystal and glitter, an ice queen that Vincent had created with unrivaled creativity and poetry.

We've never given up on each other. Vincent was with me, beside me, at every appearance on the stage, as a show girl, for my concerts, my film clips, my fashion shoots, all kinds of engagements that he was kind enough to say were, in themselves, an art form.

He was there at the Crazy Horse, where he collaborated on the sets and the staging, because Vincent has a sense of the atelier. He was there for the epic *Don Quichotte contre l'Ange Bleu*, for which he created the costumes. In this musical, I played Marlene Dietrich, a doll equal parts fairy and French cancan, who caused a miserable Don Quixote to die of love. Vincent sculpted a beautiful suit of armor, a cross between the Renaissance and a blonde Berlin Venus, top hat, sparkling pink bunny suit with a touch of neon, a dress with a built-in showerhead for the dance of the seven veils. In another scene, I was made up like a Rolls-Royce, illuminated headlights taking the form of a bra; and finally, a showgirl, a windmill, with blades turning on her butt, all in a Dada aesthetic direct from a revolutionary manifesto.

When I was asked to play the Alexandre Dumas character Milady in a revamped version for a television adaptation, I was enthralled by the idea of playing this tragic and passionate heroine. I immediately saw myself in a gothic, courtly universe that, in my eyes, could only be recreated with the fortitude and invention of Vincent.

He embarked on a titanic work, recreating Velásquez-like eighteenth-century costumes—paniers, collars, doublets, thigh boots, guimpes, and more—in a futurist style. All in leather and animal skins, shaped and metal plated in the great tradition of Cordoba leathers. I found myself in a voluptuous suit of armor.

I was ecstatic when asked to direct Verdi's *La Traviata*. It was an enormous undertaking, bringing together more than a hundred people. Happily, my producers gave me carte blanche to choose the choreographer as well as the set and costume designer. Naturally, for the latter two roles, I turned to Vincent.

He took inspiration from the amazing draftsman Grandville, who was celebrated for his flower women, botanical creatures with a fantastical romanticism, as if plucked from the costume balls of the Second French Empire. As for the sets, he evoked, with dreamlike extravagance, the gothic inking of Victor Hugo.

Monoprix

An invitation from Monoprix is not to be refused. Introduced by their talented ambassador and one of my protégées, Diane Ducasse, I met the fabulous Monoprix team. Full of enthusiasm for my work, and placing no limits on my imagination, they set the tone.

I needed to tell a story that connected the entire project. Telling stories is something I know; it is always the starting point for my work. The question was, in which season would my collection be launched. They thought Christmas, and I explained that, for me, this was the most depressing time of year, and that I preferred summer, spring, the sun! And as I was talking, the image came of a lunch on the grass, of an old-fashioned picnic with its plates, its accessories, from Monet to the films of Renoir, a gentle, artistic sense of nostalgia, without flip-flops or tank tops! A luncheon in nature, surrounded by animals, like one of Grandville's illustrations.

The bee is a lantern, the elephant a ceramic stool, the swan a teapot, wine and water are served from porcelain fish, the tablecloth is checkered with frogs, rabbits, and mice singing, dancing, and playing the guitar! The metal table has frog's legs and the chair is a wrought-iron bird, the bread board a turtle, the salt and pepper, ladybugs. We toast one another in glasses of music, lying back on a striped floral futon. More flowers on the pajamas. A fairy-tale sun king reigns over everything: we follow him on the enameled plates; he shines on the carpet until he is reflected in his own mirror. With more music, coffee is offered on a lacquered tray, its animal print jumping from one cup to another.

Under a striped tent flying through the sky, time is suspended. We take out our notebooks to sketch the sweet moments in a bucolic watercolor, and with a brush we immortalize the last rays of the sun crossing the trees. It is hard to believe: it's already time to go home and we lament the passage of a summer that has already vanished. We will pack away our vacations, our summer dreams, in boxes strewn with colored flora. We remember the season, the sun, and the songs.

MONOPRIX

la mode printanière

LE MUSÉE EN VACANCES

Crème SUPER HYDRATANTE

DOCUMENTATION, ÉCHANTILLONS : chez nos dépositaires agréés ou **PHEBEL**, service «Ventes» — PUTEAUX (Seine)

Quelques jours en plein air

**LUNCHEON ON THE GRASS
WITH THE MUSE ANAËLLE**

Quel chic !

DÉJEUNER SUR L'HERBE

Mon tricot

ET VOUS SAVEZ ! c'est moi qui les fais...

POUR RIRE

AS IF IN A FAIRY TALE, ANIMALS COME TO LIFE

Brillantine
LUSTRALE
CADORICIN

THE WONDROUS MONOPRIX TEAM CREATED EXTRAORDINARY OBJECTS!

Ne coupez pas la cuticule !

CES BÊTES ONT LEUR HISTOIRE

"Mon Manège à Moi"

When the Covid-19 epidemic hit Paris, we had to flee the Rue Royale for a new address, but before we left, I wanted to create one last interior there, in that place I always imagined in perpetual renewal; I wanted to surprise visitors over several months.

We had the walls repainted, changed the wallpaper, changed the functions of the rooms, and then ran through the galleries looking for curiosities. Thus, a bronze octopus chandelier by Régis Mathieu transformed the fresco *Le Jardin Carnivore* into an aquarium. The once blue dining room became its opposite, with a trompe l'oeil black-and-white wallpaper. The furniture I designed for Oka, in white marble and plaster, adorned the space, in dialogue with this palette. The black-and-white marble Centaure table, in the center a Philippe Valentin chandelier, on the wall my Pégase sconces, their design reminiscent of a Cocteau drawing. The salon also changed outfits, a yellow sky dominating a circular carpet of warm velvet that was in conversation with the totems, works by Nicolas Lefebvre. A Patrick Naggar table in steel was framed by two brown and copper consoles by Éric Schmitt.

The concept of this apartment was for my objects to converse with those of artist and designer friends that I have met by chance and through luck. The office was filled with wire figures by my friend Charles Serruya, and the surprising floral collages in the small bathroom were by Friquette Mondino. By the time I was satisfied with the result, Paris was suspended in lockdown. My days were haunted with the sadness of seeing my last décor without a single memento … then, the miracle of Instagram—invaluable for discovering the unknown through their work—led me to meet Julien Drach. I had been admiring his work for several weeks: this photographer's still lifes are so poetic, your dreams take flight. One day, I dared send him a message: "I created an interior in a space on Rue Royale—would you be interested in photographing it?" He said yes immediately. The appointment was fixed for a sunny day; I crossed the Place de la Concorde, immersed in a metaphysical void. In this end-of-days atmosphere, the meeting was instantly friendly. Mysteriously, we felt like we already knew each other, and during the visit we talked non-stop. He explained our parallel lives. It started with the address: as a child, he had lived with his father, the director Michel Drach, at number 10 Rue Royale. Then I discovered that his mother was Marie-José Nat, whose lawyer was none other than Pierre Hebey, who also represented my uncle Jorge Semprún. Julien remembered the lawyer's elegant wife, Geneviève. I told him about my aunt and uncle, Colette and Jorge, who had introduced me to this circle. He had already met them!

Seeing this photographer, whose work I admire, so in tune with my work and with this place, gave me an idea. I gave him the keys and told him he could visit whenever he wanted and photograph the apartment as he liked. I preferred to leave him alone to work at his own pace. The result was a series of photos, mysterious and enigmatic, of an abandoned place. Everything I love! Knowing who shares such a predilection, I immediately called Martina Mondadori, creator of *Cabana* magazine, and proposed the idea. She was equally seduced by the images—she offered fourteen pages, and these will remain my most treasured memory of Rue Royale, and thus close, thanks to chance, a chapter that will remain with me all my life.

JULIEN DRACH
CREATES POETIC
PHOTOGRAPHS
IN RUE ROYALE

IL EST 10H UN MOMENT L'ATTENTE

DU BONHEUR

I DISCOVERED
JULIEN DRACH
ON INSTAGRAM

IN THE EMPTY APARTMENT DURING THE PANDEMIC

Paris

NOUS AVONS "NOËLISÉ" UNE MAISON

THE WALLS ARE ADORNED WITH A NEW DÉCOR

COURRIER DU CŒUR
PAR MARCELLE

MELON
HARICOTS
AUBERGINES
CAROTTES
TOMATES
PETITS-POIS

FRUITS

POISSONS
CRUSTACÉS

13 STELLAR ATTRACTIONS

LETTRE DE PARIS

THIS EPHEMERAL DÉCOR VANISHED AS IF BY MAGIC!

Plus je la porte plus j'aime ma

Acknowledgments

Vincent Darré expresses his sincere gratitude to:

Sylvie Adigard
Isabelle Adjani
Akis
Colette Andelman
Sarah Andelman
Adriana Asti
Stéphane Aubert
Catherine Baba
Xavier Barroux
Sylvie Barsacq
Elena Baxter
François Belfort
Vanessa Bellugeon
Marie Beltrami
Laurence Benaïm
Marisa Berenson
Pierre Bergé
Olivier Bériot
Alexandre Biaggi
Jacques Blanc
Jean-Pierre Blanc
Frédéric Bodenes
Thierry Boutemy
Marie-France Boyer
Christian Braekman
Antoine Brancardo
Cyril Brulé
Xavier Brunet
Isabella Capece
Jenny Capitain
Paula Caprelli
Pierre Cardin
Coline Carrasco
Sharon Carty
Amira Casar
Sergio Castellitto
Anne Chabrol
Aline Chastel
Pierre Chevalier
Sandro Chia
Silvia Colasanti
Anne-Marie Colban
Grégoire Colin
Cécile Coquelet
Matthieu Cossé
Oleg Covian
Madison Cox
Philippe Croset
Olivia Da Costa

Natascia Dal Pozzo
Natalie David-Weill
Josée Dayan
Fratelli de Angelis
Pierre Debeaulieu
Alix de Chabot
Sylvie de Chirée
Didier Delmas
Hubert de Malherbe
Erwan de Rengervé
Fleur Demery
Julie Depardieu
Dominique Deroche
Anabelle d'Huar
Arielle Dombasle
Valérie Donzelli
Julien Drach
Isabelle Dubern
Diane Ducasse
Justine Dumand
Pierre-Alexis Dumas
Sophie Dumas
Alexandre Dumont
Giulio Durini
Alexandra Elbim
Benjamin El Doghaïli
Jérémie Elkaïm
Phillipe Eveno
Benjamin Eymere
Matteo Falcier
Max Farago
Anna Fendi
Carla Fendi
Maria Teresa Fendi
Silvia Fendi
Giorgio Ferrara
Hélène Fillières
Gaspard Finet
Christelle Fossi
Robert Four
Bernard Fournier
Pietro Arco Franchetti
Pierre Frey
Stéphane Fritsch
Olivier Gabet
Lea Giudicelli
Jacques Grange
Lorenzo Grante
Sandrine Guichard
François Halard
Frank Halard

Geneviève Hebey
Lucille Imbert
Eva Ionesco
Jean-Pierre Jais
Marie-José Jalou
Vojta Janyska
Anna Jaoui
Éric Zion Jaoui
Philippe Jarrigeon
Mathias Ary Jan
Marie Kalt
Philippe Katerine
Nicolas Ker
Nguyen Quoc Khanh
Farida Khelfa
Sandrine Kiberlain
René Korman
Claudine Lachaud
Ande La Conté
Karl Lagerfeld
Déborah Lalaudière
Brigitte Langevin
Dísella Lárusdóttir
Nicolas Lefèvre
Jean-Yves Le Fur
Valérie Lemercier
Pierre Le-Tan
Nathalie Lesage
Charles Leung
Bernard-Henri Lévy
Manu Llopis
Kevin Llopis
Mafalda Lopes
Véronique Lopez
Pierre Léon Luneau
Ali Mahdavi
Anaëlle Maman
Gianluca Margheri
François Margolin
Monsieur Marin
Audrey Marnay
Thibault Mathieu
Lily McMenamy
Samuel Mercer
Olivier Merveilleux du Vignaux
Patrick Mille
Friquette Mondino
Mauro Mongiello
Vincent Mongourdin
Gilles Muller
Pascale Mussard

Patrick Naggar
Aristide Najean
Élodie Navarre
Victoria and Philippe Niarchos
Mauro Nicoletti
Marie Noulez
Oka
Anne Orlowska
Katarzyna Otczyk
Giorgio Pace
Lucien Pagès
Fabrice Paineau
Pierre Passebon
Anna Patalong
Benjamin Patou
Pierre Pelegri
Gaia Petrone
Martin Pietri
Sophie Pinet
Salomé Pirson
Alexandre Poulaillon
Antonia Poux
Franceline Prat
Colombe Pringle
Marine Prud'hon
Patricia Racine
Silvia Regazzo
Yann Revol
Marta Rinaldi
Danielle Sabatier
Clara Saint
Cédric Saint André Perrin
Yves Saint Laurent
Valérie Samuel
Sofia Sanchez
Donatella Sartorio
Hervé Sauvage
Jérôme Savary
Manon Savary
Éric Schmitt
Raphaël Schmitt
Niels Schneider
Anne Sebaoun
Charles Serruya
Jennifer Shorto
Eugenia Sierko
Anna Sigalevitch
Irene Silvagni
Juliette Sirinelli
Franca Sozzani
Luca Stoppini

François Tajan
Delphine Ta-Pidebois
Matthieu Tarot
Pierre Tattevin
Olivia Temin
Dorothée Thévenin Lussey
Rupert Thomas
Elie Top
Goran Topalovitch
Benedetta Torre
Arthur Van Den Bosch
Dominique Van Den Bosch
Pierrick Van Troost
Jean-Baptiste Varenne
Mélodie Vasseur
Philippe Vernaise
Alberto Vignatelli
Alexandre Vilgrain
Denise Vilgrain
Sandrine Viollet
Ariel Wizman
Rémy Yadan
Olivier Zahm

Very special thanks to:
AA Corporation
AD France
AD Intérieurs
Agence Malherbe
Agence Viva
Artcurial
Atelier Caraco
Ateliers d'Art des Musées Nationaux
Atelier Mériguet-Carrère
Atelier Métropole
Atelier Simon-Marq
Au Fil des Couleurs
Blanc Carrare
Charvet
Codimat
Cointreau
Colette
Declercq Passementiers
Design et Nature
Dior
ELLE Décoration
Émaux de Longwy
Fondation Durini
Fondation Pierre Bergé
Fred Paris

Galerie du Passage
Galerie Dutko
Galerie Magazzino
Hôtel Prince de Galles
Invisible Collection
La Biennale des Antiquaires
Laboratorio Pieroni
Lancel
Lanzani
La Redoute
La Vie en Bronze
Le Bon Marché
Le Grand Palais
Le Ministère de la Culture
Les Puces de Saint-Ouen
Le Ritz
Librairie Galignani
L'Officiel
Lucien Pages
Luxury Living
MAD
Maison Rapin
Makes Project
Mathieu Lustrerie
Maxim's
Mobalpa
Monoprix
NOMAD
Opéra-Comique
Opéra en Plein Air
Paglialunga
Parallel Studio
Phelippeau Tapissier
Poltrona Frau
Sartoria Farani
Spoleto Festival
The World of Interiors
Toulemonde Bochart
VLT Transports
Vogue Paris
ZionSay

Vincent Darré also extends
his sincere thanks to
Suzanne Tise-Isoré,
Lara Lo Calzo,
Bronwyn Mahoney,
and Joseph Tsai
of Flammarion,
Style & Design Collection,
and to Atelier Frédéric Claudel.

Photographic Credits

© David Atlan: p. 110
© Gaëtan Bernard: pp. 18, 19.
© Pascale Béroujon: pp. 10, 11, 12, 13.
© Olivier Chalvron: p. 137.
© Olivia Da Costa: pp. 25, 27, 28, 29.
© Vincent Darré: pp. 86, 87, 88, 89, 90, 91.
© Didier Delmas: pp. 30, 31.
© Julien Drach: pp. 202, 203, 204, 205, 206, 207, 208, 209, 210, 211.
© Florant Drillon: pp. 168, 169, 170, 171.
© Max Farago: pp. 100, 101.
© François Halard: pp. 92, 93, 94, 95.
© Claire Israël: p. 139.
© Philippe Jarrigeon: pp. 116, 117.
© Gerald Krischek: pp. 154, 155.
© Karl Lagerfeld: pp. 42, 43.
© Deborah Lalaudière: pp. 162, 163.
© Fabrice Le Dantec: pp. 48, 49, 50, 51, 52, 53, 54, 55, 56, 57, 58, 59, 60, 61.
© Jarri Kim Mariani and Maria Laura Antonelli: pp. 116, 117, 118, 119.
© Yann Revol: pp. 64, 65.
© Sofia Sanchez and Mauro Mongiello: pp. 16, 17.
© Hervé Sauvage: pp. 20, 21, 22, 23.
© Charles Serruya: pp. 146, 147.
© Eugenia Sierko: pp. 194, 195, 197, 198, 199.
© Pierrick Van Troost: pp. 82, 83, 217.
© Frédéric Vasseur: pp. 110, 111 (photographs of the décors)
© Pierrick Verny: pp. 32, 33, 34, 35.
© Luc Vincent: pp. 76, 77.
© Olivier Zahm: pp. 96, 97, 98, 99.

Every effort has been made to identify photographers and copyright holders of the images reproduced in this book. Any errors or omissions referred to the Publishers will be corrected in subsequent printings.

EXECUTIVE EDITOR
Suzanne Tise-Isoré
Style & Design Collection

EDITORIAL COORDINATION
Lara Lo Calzo

GRAPHIC DESIGN
Mélodie Vasseur

TYPESETTING
Joseph Tsai

TRANSLATION FROM THE FRENCH
Bronwyn Mahoney

COPY EDITING AND PROOFREADING
Lindsay Porter

PRODUCTION
Corinne Trovarelli

COLOR SEPARATION
Atelier Frédéric Claudel, Paris

PRODUCTION OF THE VIDEO "LES AVENTURES DE VINCENT DARRÉ"
ZionSay

Printed in Barcelona (Spain) by Indice

Simultaneously published in French as *Le Petit Théâtre de Vincent Darré*
© Flammarion S.A., Paris, 2021
© Maison Vincent Darré, 2021

English-language edition
© Flammarion S.A., Paris, 2021
© Maison Vincent Darré, 2021

All rights reserved for all countries. No part of this publication may be reproduced in any form or by any means, electronic, photocopy, information retrieval system, or otherwise, without written permission from Flammarion S.A.

Flammarion, S.A.
87, quai Panhard-et-Levassor
75647 Paris Cedex 13
editions.flammarion.com
@styleanddesignflammarion

21 22 23 3 2 1
ISBN: 978-2-08-026395-7
Legal Deposit: 10/2021